MW00824074

20 WAYS TO DRAW A MUSTACHE

AND 44 OTHER FUNNY FACES AND FEATURES

CARA BEAN

A Sketchbook for Artists, Designers, and Doodlers

Quarry Books
100 Cummings Center, Suite 406L
Beverly, MA 01915

quarrybooks.com • craftside.typepad.com

© 2014 by Quarry Books
Illustrations © 2014 Cara Bean

First published in the United States of America in 2014 by
Quarry Books, a member of
Quarto Publishing Group USA Inc.
100 Cummings Center
Suite 406-L
Beverly, Massachusetts 01915-6101
Telephone: (978) 282-9590
Fax: (978) 283-2742
www.quarrybooks.com
Visit www.Craftside.Typepad.com for a behind-the-scenes peek
at our crafty world!

ISBN: 978-1-59253-920-8

Library of Congress Control Number 2014932279

Design: Debbie Berne

Printed in China

All rights reserved. No part of this book may be reproduced in
any form without written permission of the copyright own-
ers. All images in this book have been reproduced with the
knowledge and prior consent of the artists concerned, and no
responsibility is accepted by the producer, publisher, or printer
for any infringement of copyright or otherwise, arising from
the contents of this publication. Every effort has been made to
ensure that credits accurately comply with information supplied.
We apologize for any inaccuracies that may have occurred and
will resolve inaccurate or missing information in a subsequent
reprinting of the book.

10 9 8 7 6 5 4 3 2 1

CONTENTS

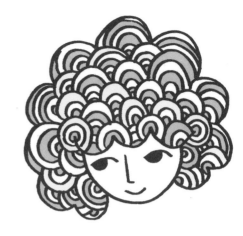

INTRODUCTION

20 Ways to Draw a Mustache is a fun and interactive book designed to help you explore a wide variety of approaches to drawing. It encourages experimentation with media and explores different ways of imagining and seeing. Inside you'll find plenty of examples to delight and inspire as well as space to add your own creations.

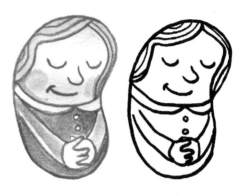

bean characters: waterproof ink, colored pencil, and watercolor

Human features, limbs, adornments, expressions, actions, and character types can be an unlimited resource for drawing inspiration. There are countless ways to depict human qualities with much creativity and playfulness. In this book you'll find forty-five themes drawn in a variety of styles. For each theme, the subject matter or shape remains the same, but the approach to drawing it differs. You will see twenty ways to draw each topic: Perhaps you can come up with twenty more?

Drawing doesn't have to be stressful or require lofty expectations. You may discover that simply drawing a theme twenty times will lead to surprising mark-making revelations. Keep in mind that mistakes and distortions are a welcome part of the process. Drawing is best when you can relax, grab your favorite pens and pencils, and just let the doodling happen. Observe what can occur when you remain open to experimentation and allow your imagination to wander. Just follow along with where your pencil would like to travel on the page. You can explore the possibilities of a shape, investigate different line qualities, and invent various ways to create textures. You will discover that the more often you draw, the more confidence you will build in regard to your artistic potential.

There is a great degree of freedom in how you may approach subject matter that interests you. For example, when we consider hair, there are countless styles in human culture and infinite ways to draw them. People watching can be a fascinating endeavor for artists. We can simply place ourselves in a public space and draw the

many hair shapes, colors, and textures that cross our path. Feel free to be experimental and disregard the rules of gravity to make things more interesting.

HOW TO USE THIS BOOK

There are twenty drawings for each theme shown. Some are very simple; some, more complex. Some are realistic while others are reduced to their most basic geometric elements. Some are rendered accurately; others ignore scale and proportion. Look at the images and select those that interest you. What is it about them that pulls you in? Can you draw something similar? Find new ways to reconfigure the shapes and lines that you see.

Some pages are blank for you to fill; others have spaces for you to draw between the images. Maybe you can combine various features to invent new characters? Perhaps you will make monsters with twenty different kinds of eyes? Maybe try putting a mustache on a cat or a beard on a dog? Create a party where only people with mullets are invited!

mustaches: waterproof ink and watercolor

lips: waterproof ink and watercolor

eyes: waterproof ink and watercolor

Become comfortable with the idea that you can express yourself through drawing. Draw in a way that surprises and captivates your imagination. Explore different drawing tools and apply different techniques. Some drawings will work and others will be less successful. Enjoy the process and interpret your mistakes as potential creative possibilities. Enjoy the idea that we can draw a mustache in as many ways as there are mustaches in existence!

DRAW 20

Mustaches

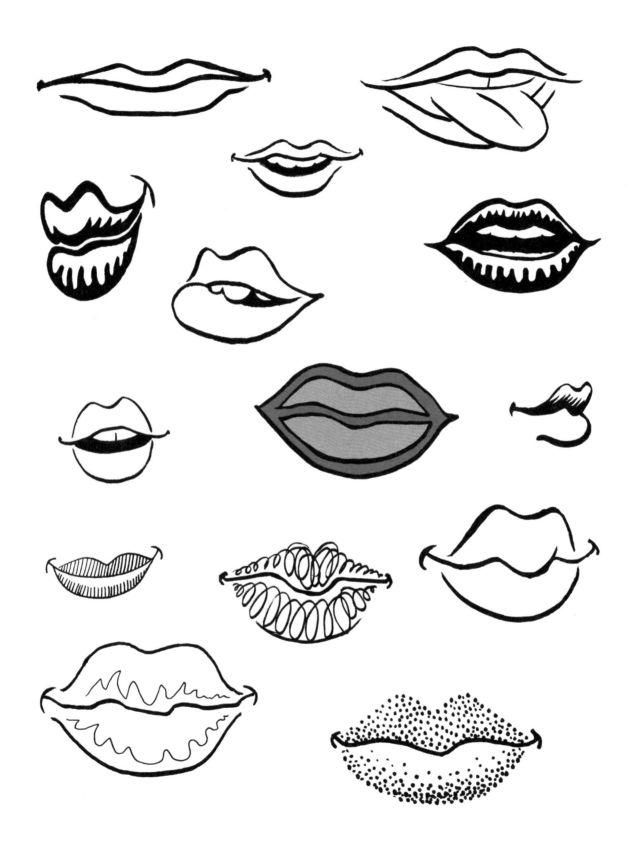

Lips

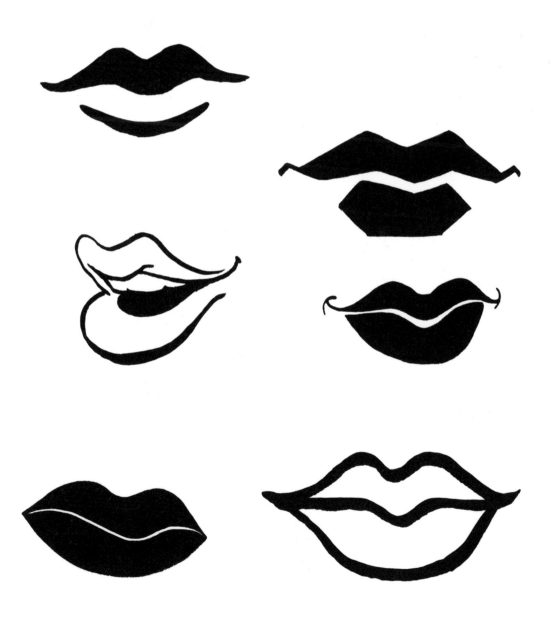

DRAW 20
EYES

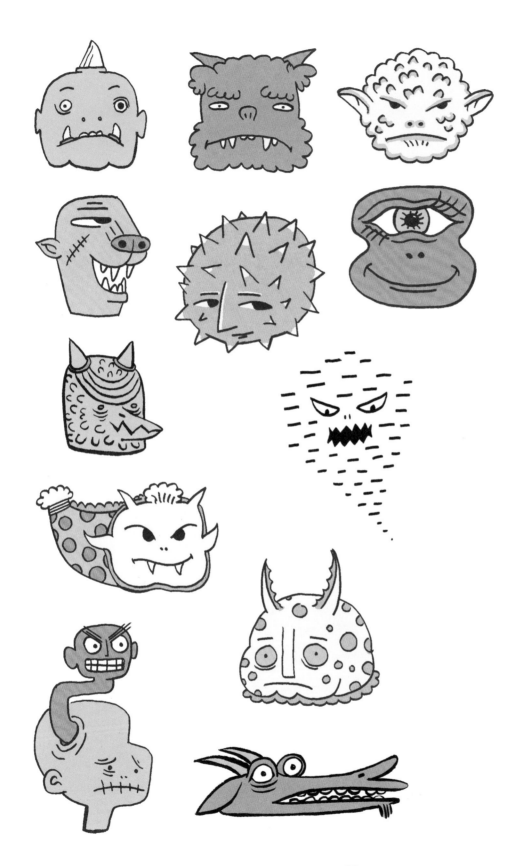

DRAW 20
Monsters

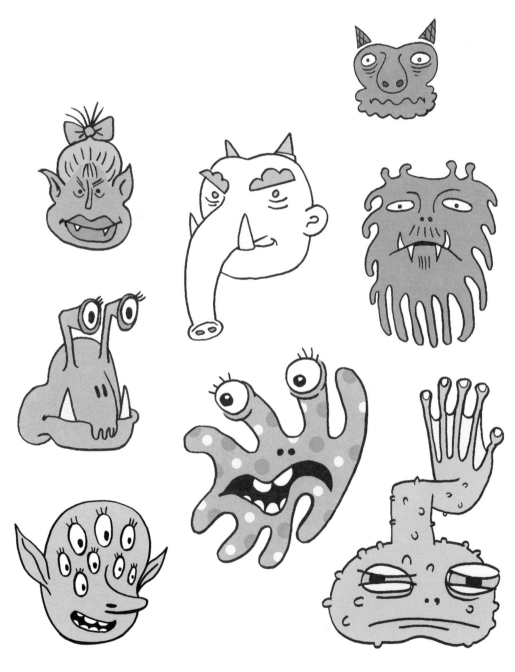

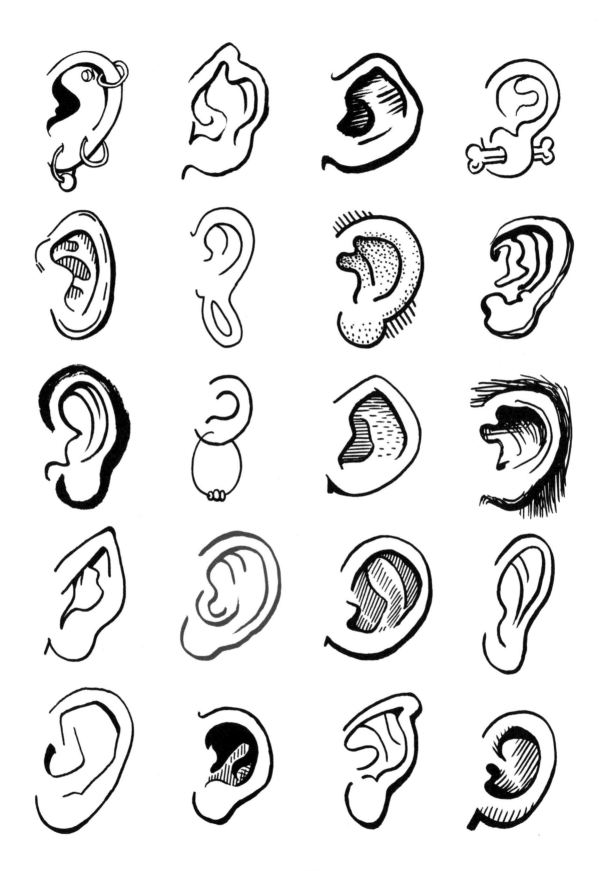

DRAW 20

Ears

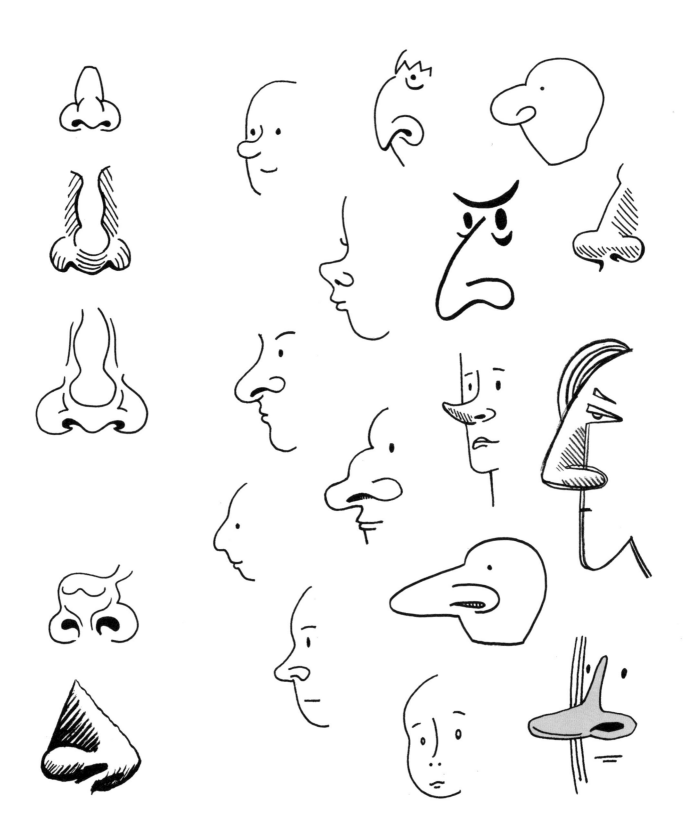

DRAW 20
NOSES

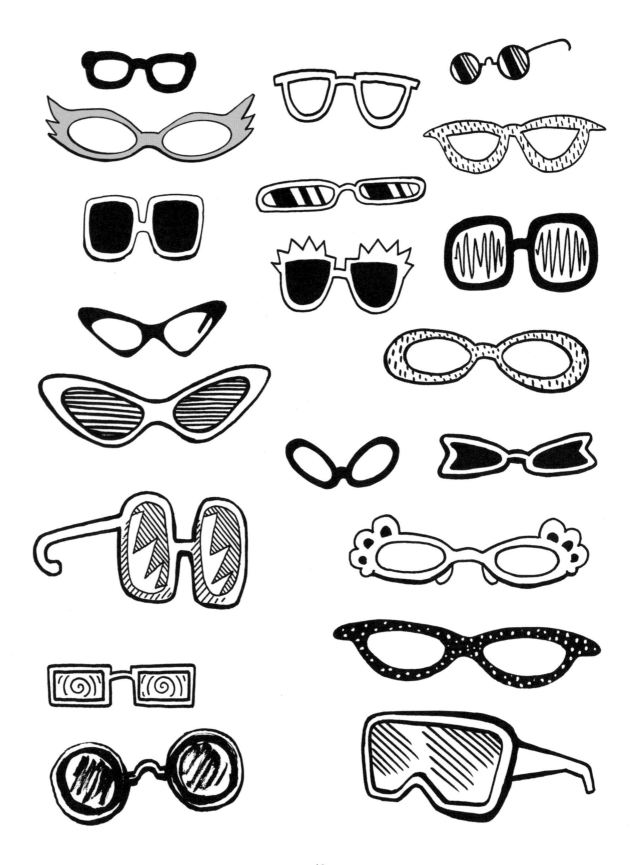

DRAW 20
EYEGLASSES

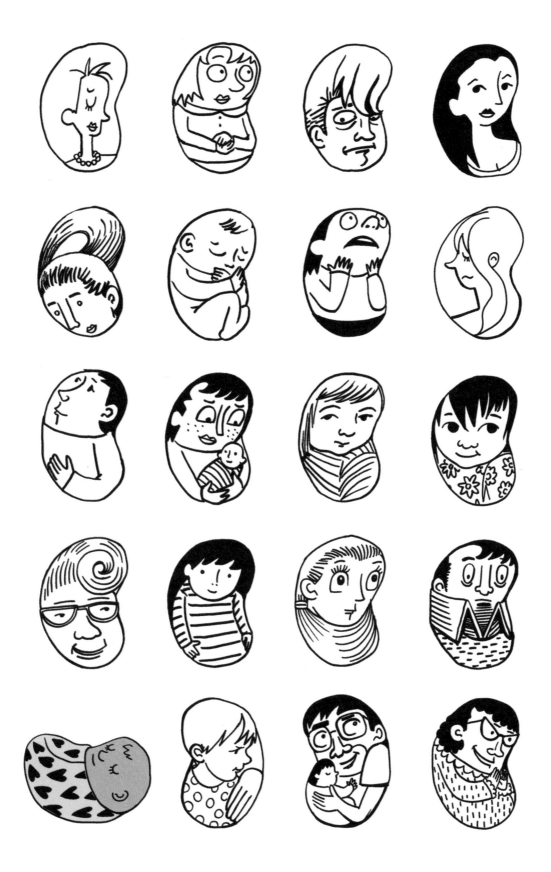

DRAW 20
Bean characters

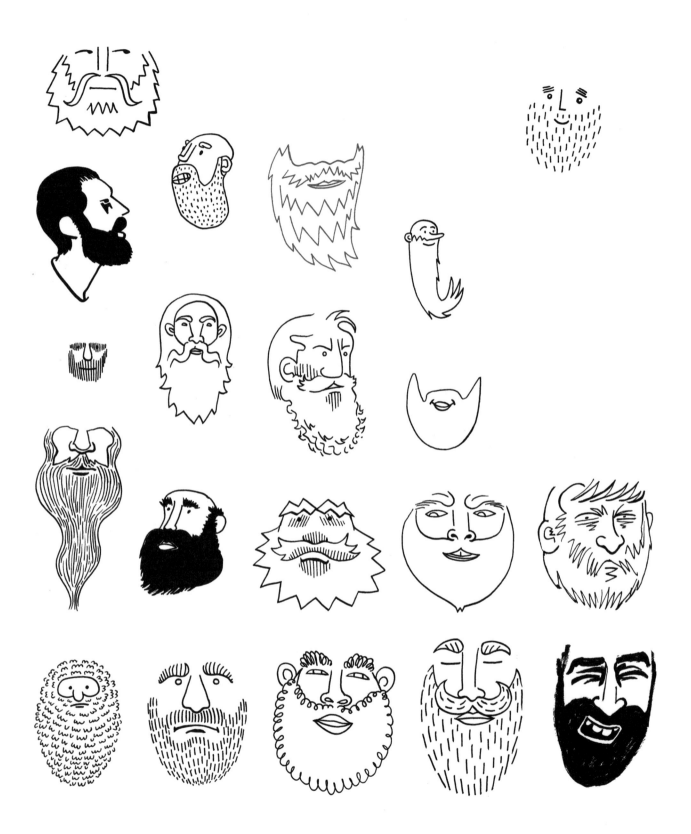

DRAW 20
Beards

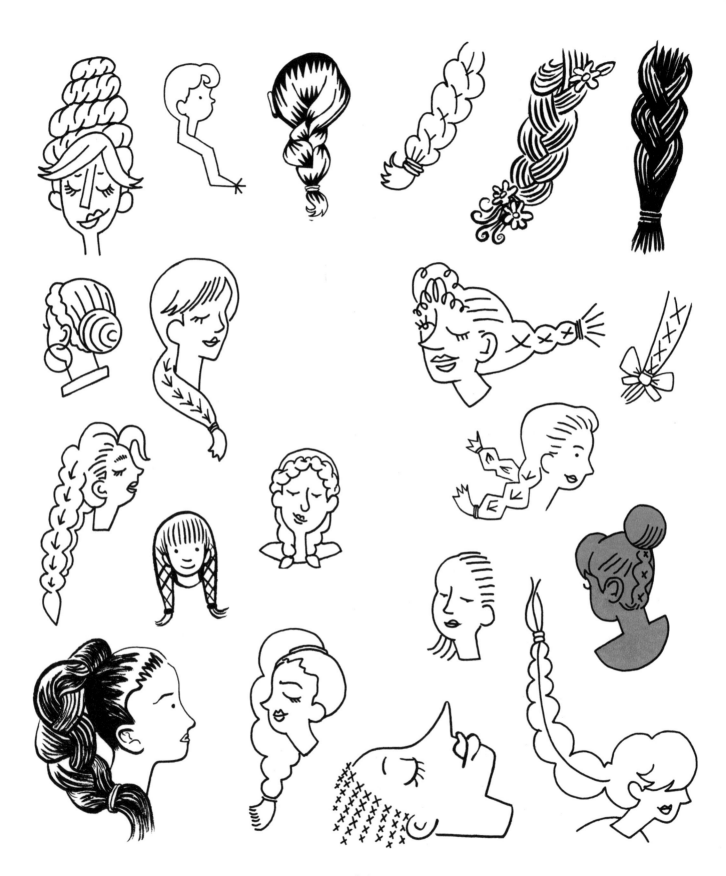

DRAW 20
Braids

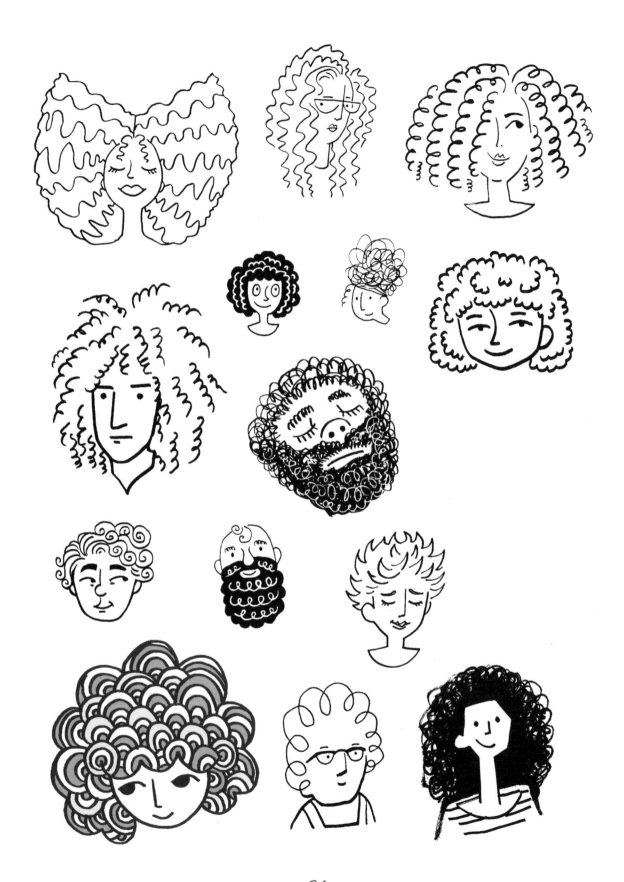

DRAW 20
CURLY HAIRSTYLES

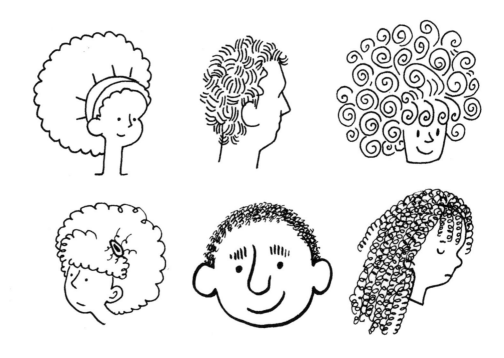

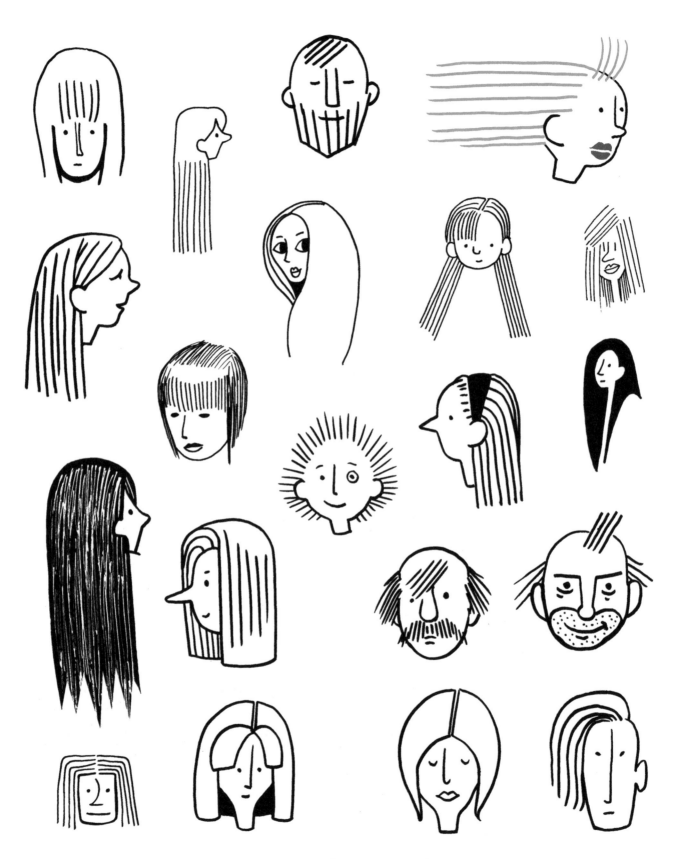

DRAW 20
STRAIGHT HAIRSTYLES

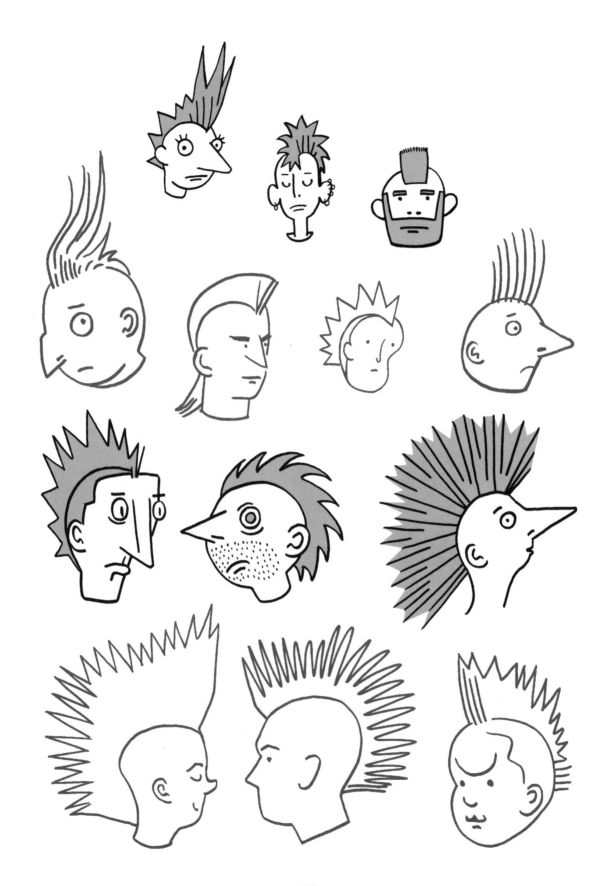

DRAW 20
Mohawks

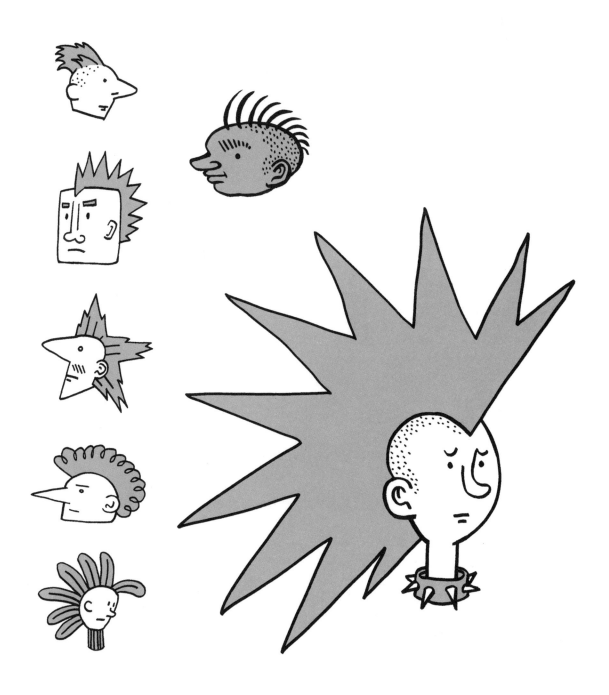

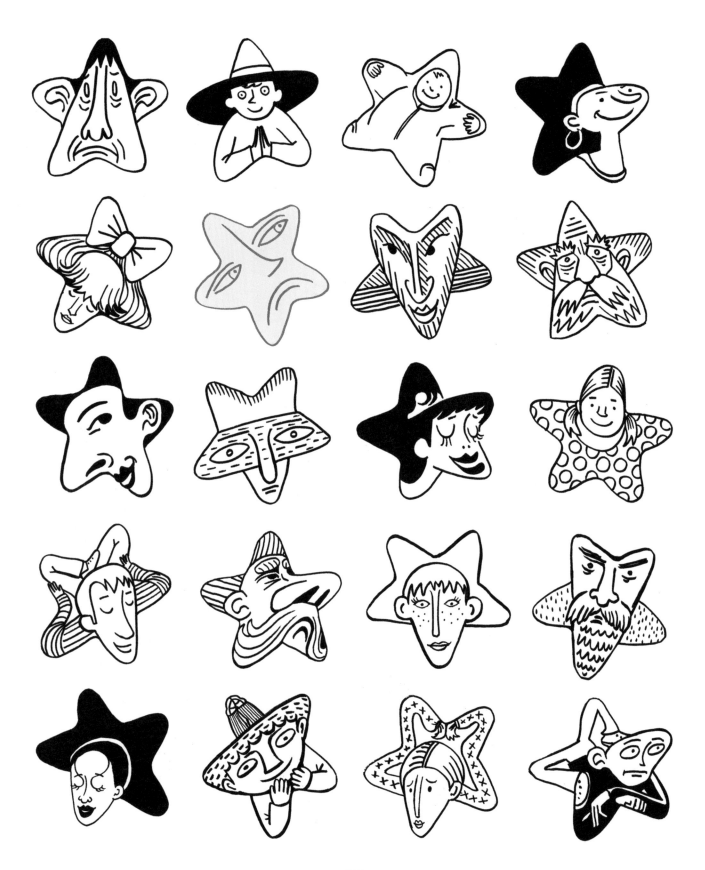

DRAW 20
Star Characters

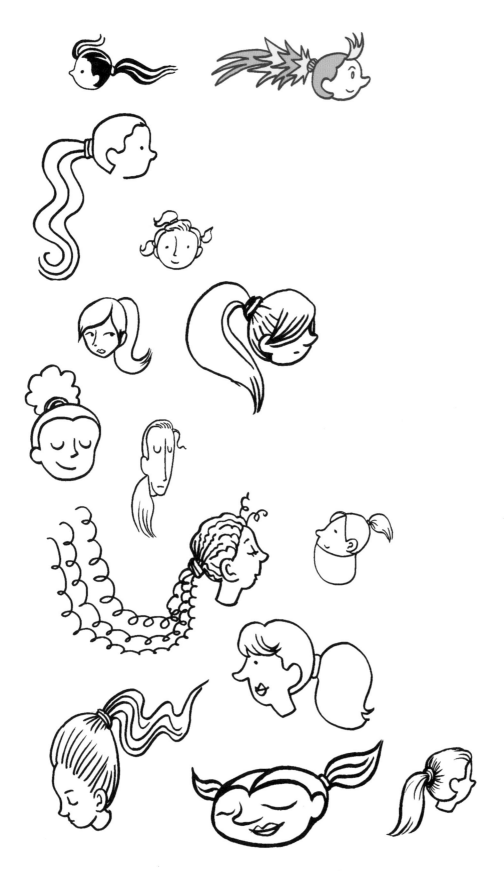

DRAW 20
Ponytails

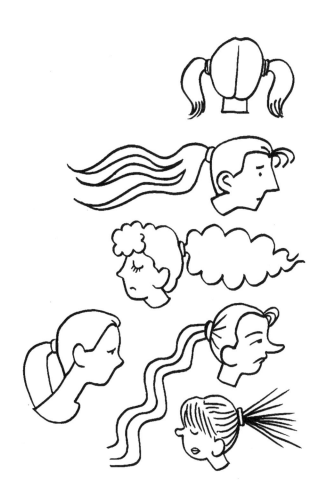

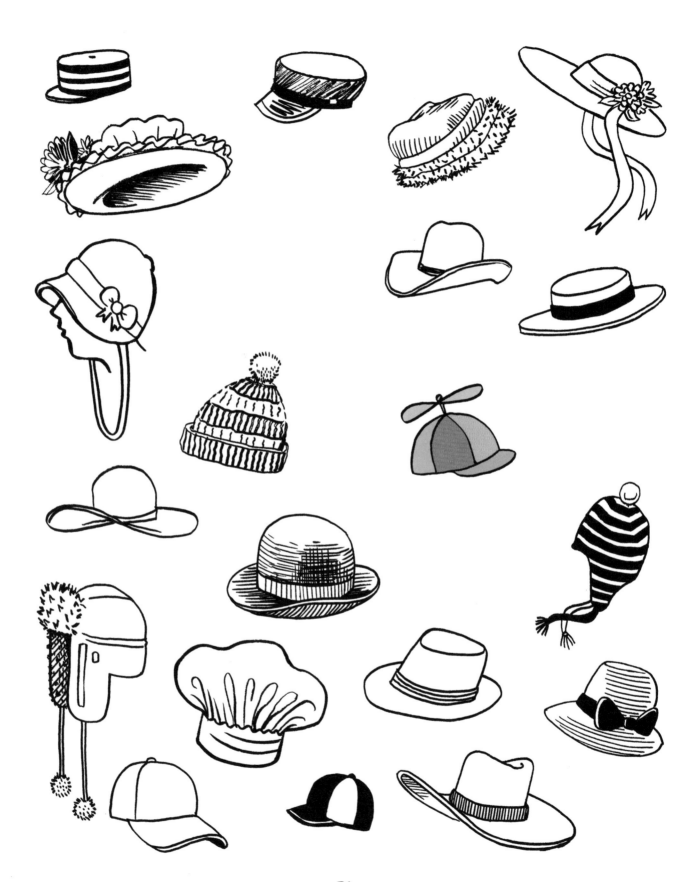

DRAW 20
HATS

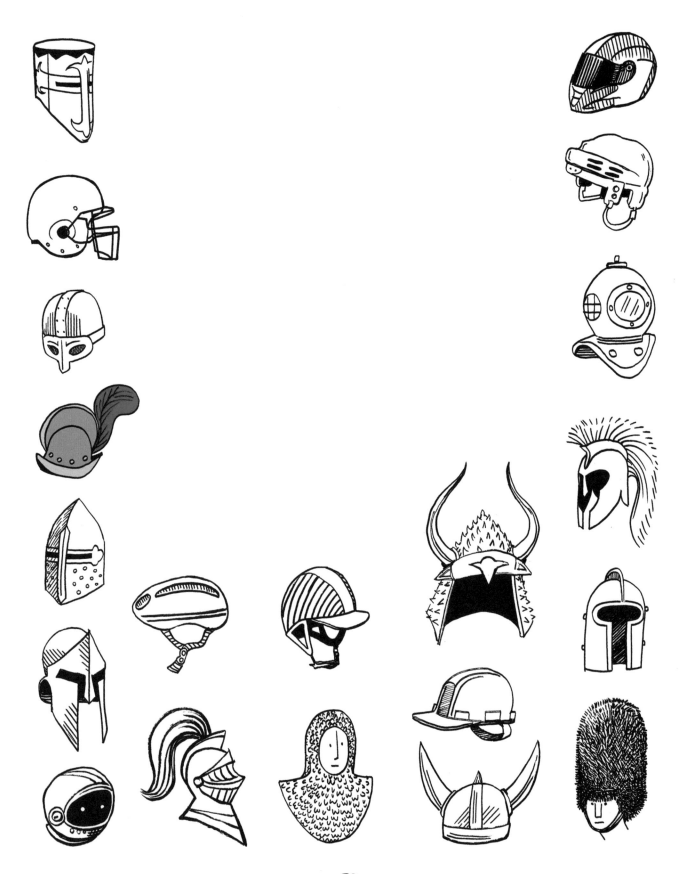

DRAW 20
Helmets

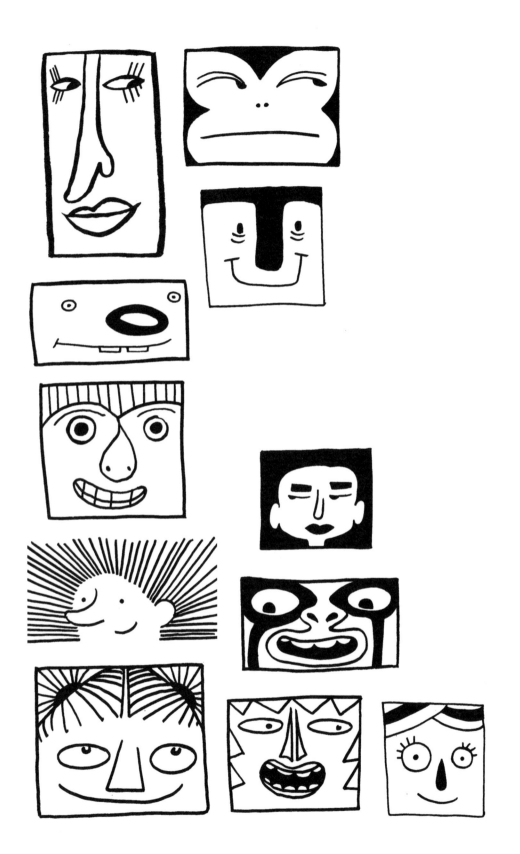

DRAW 20
BLOCK CHARACTERS

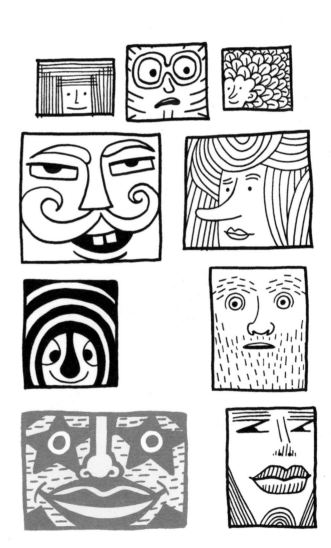

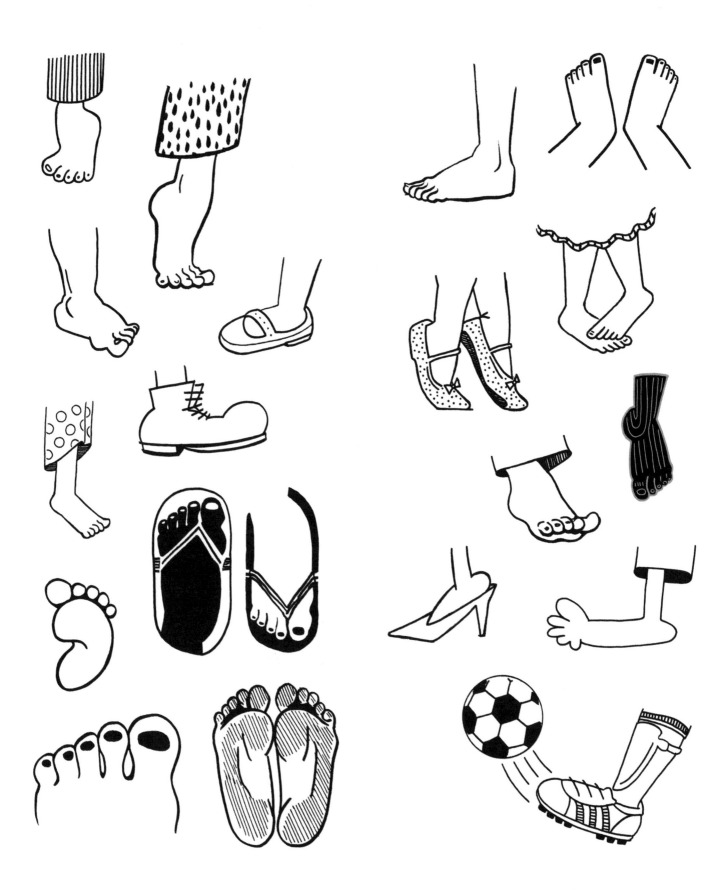

DRAW 20
Feet

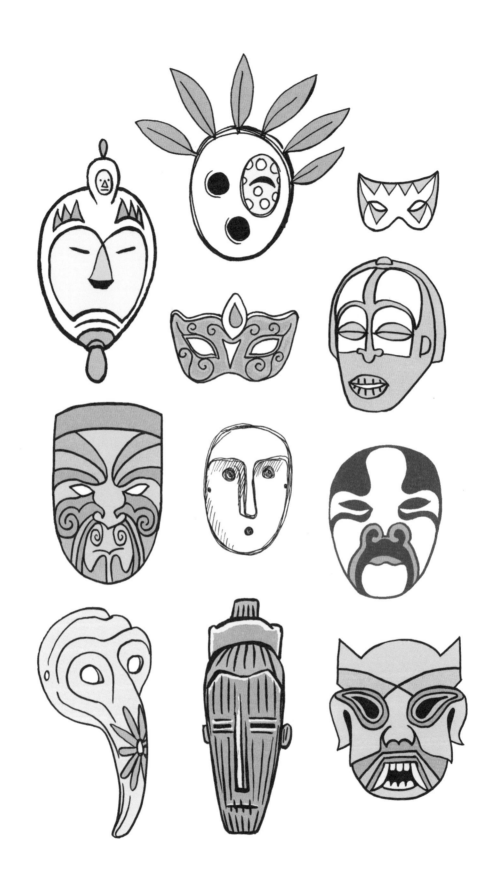

DRAW 20
MASKS

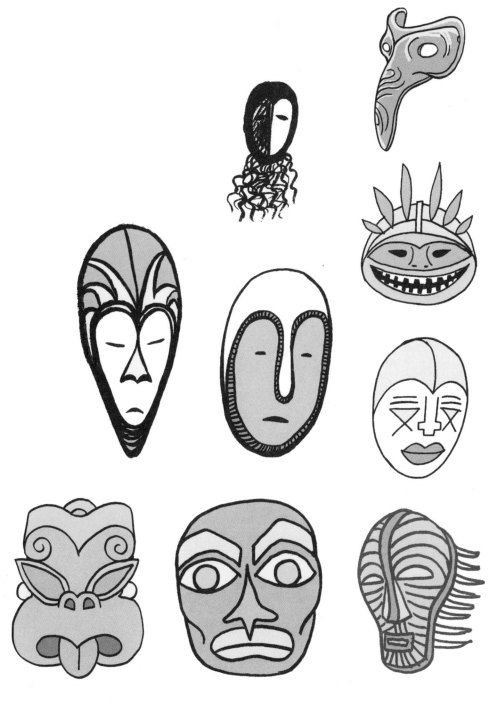

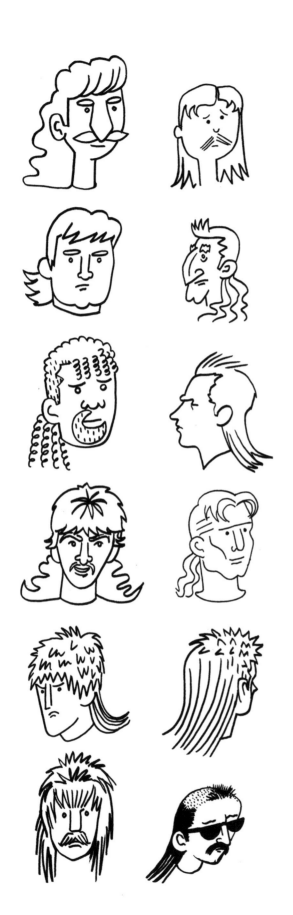
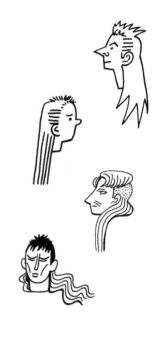

DRAW 20
Mullets

DRAW 20
EYEBROWS

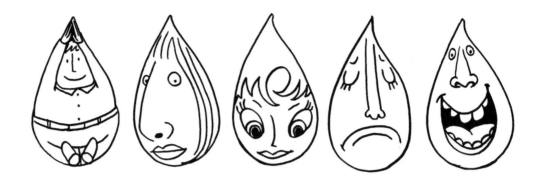

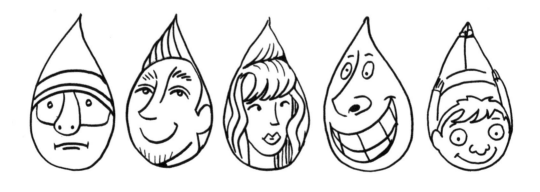

DRAW 20
Teardrop Faces

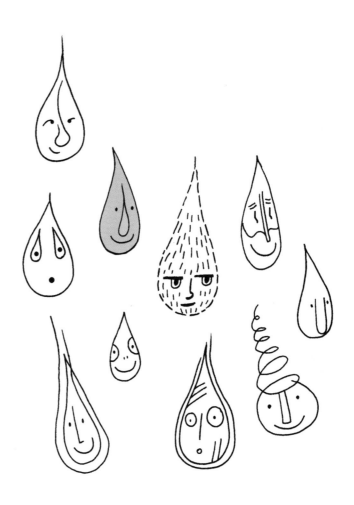

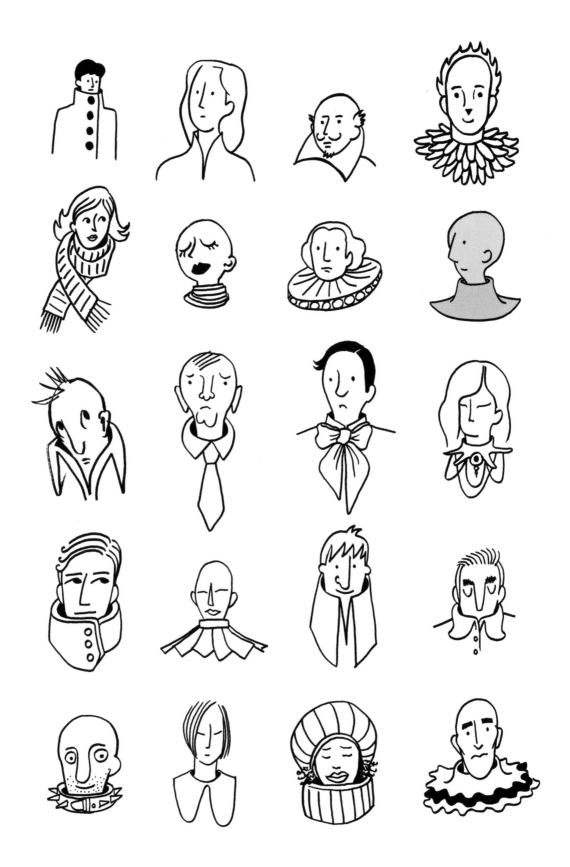

DRAW 20
COLLARS

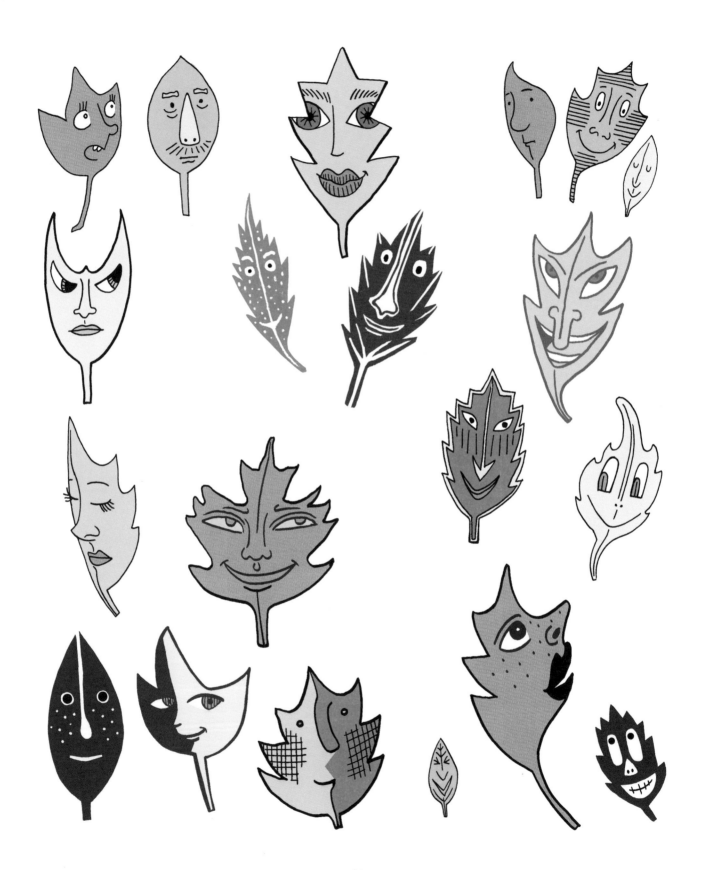

DRAW 20
Leaf Characters

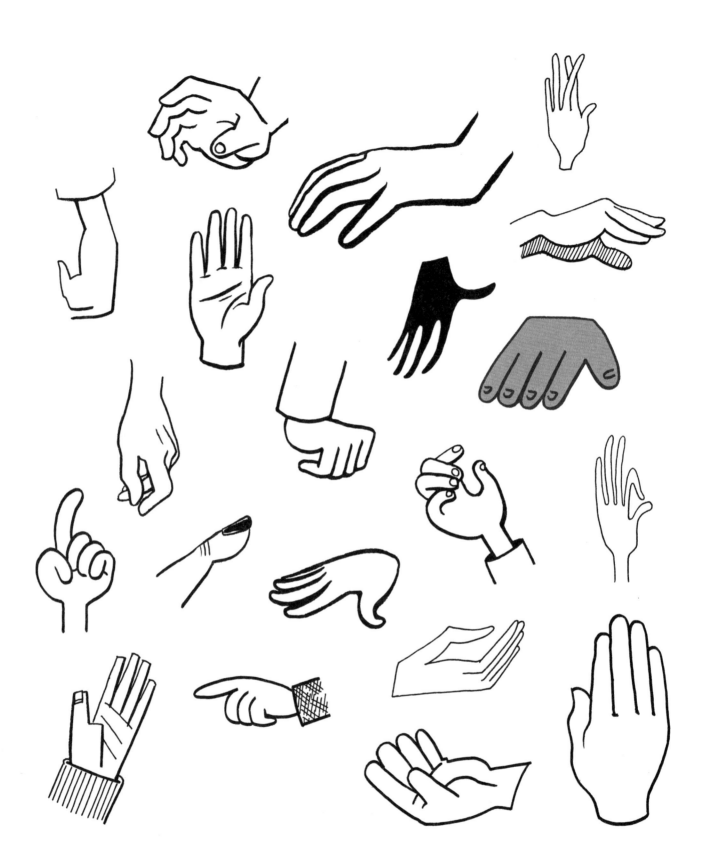

DRAW 20
Hands

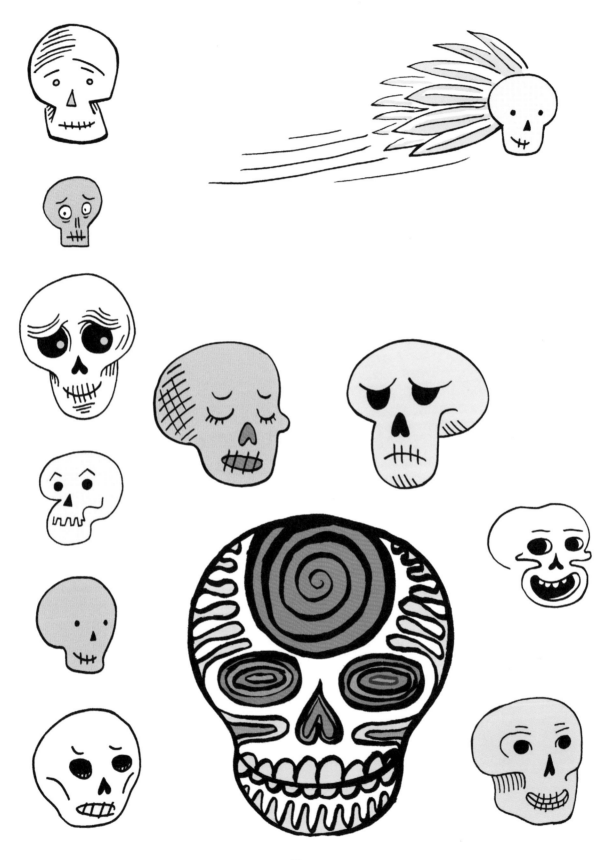

DRAW 20
SKULLS

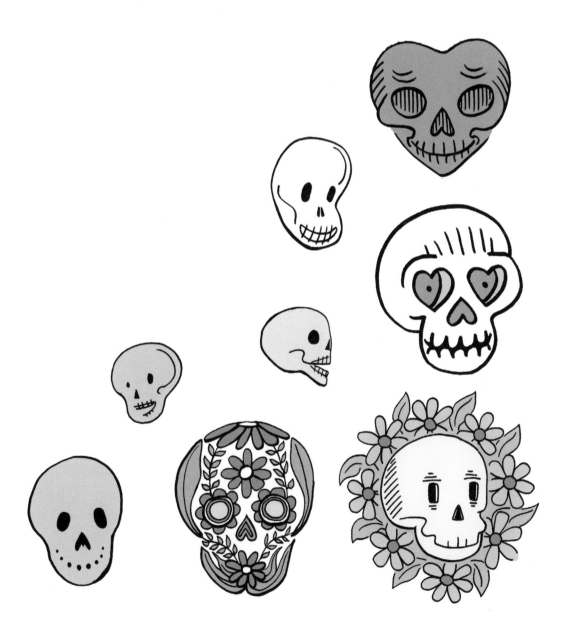

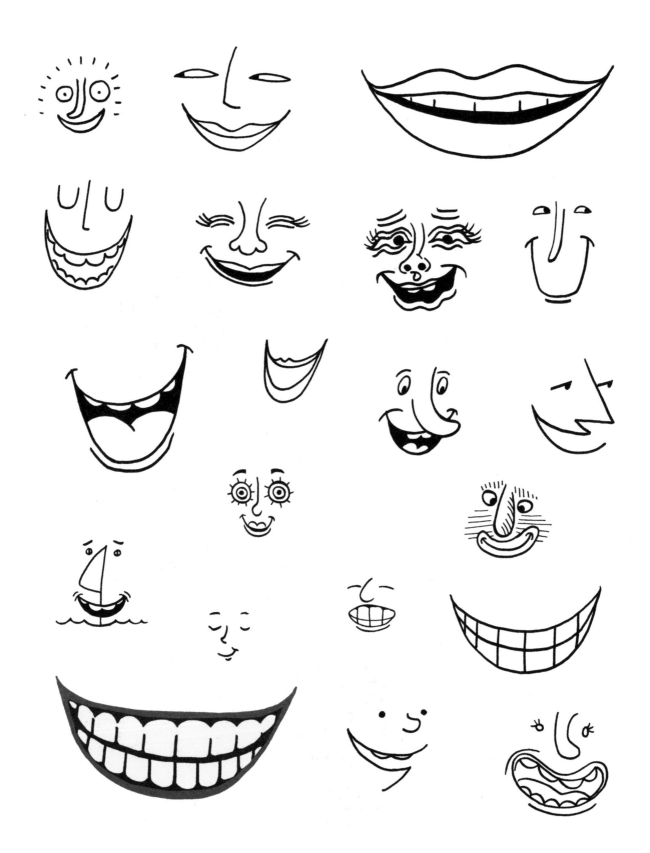

DRAW 20
Smiles

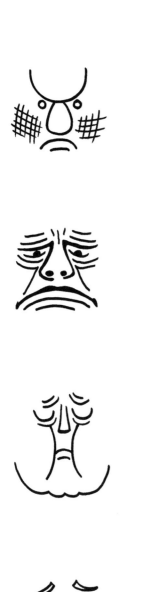

DRAW 20
FROWNS

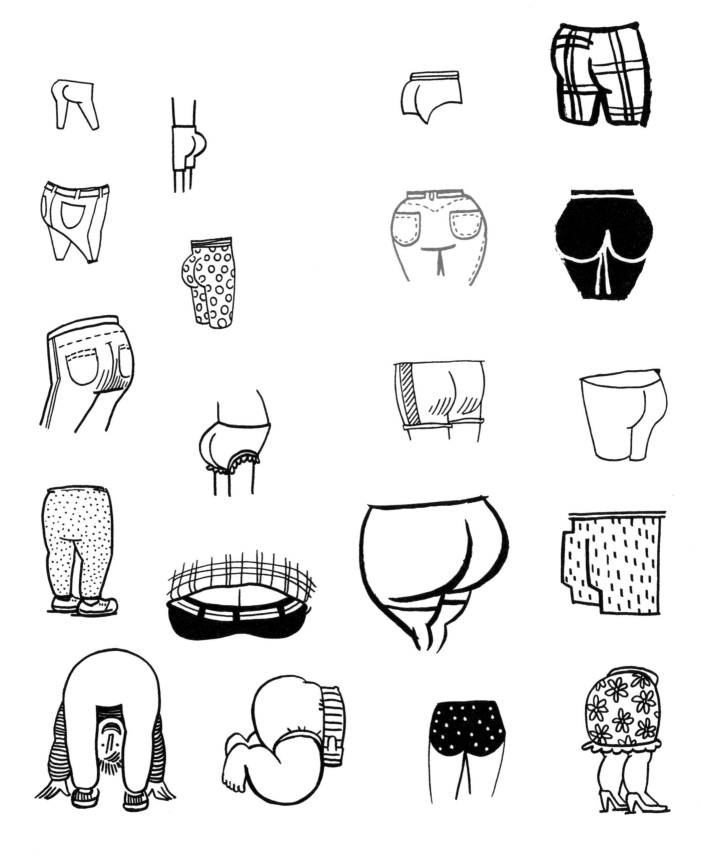

DRAW 20
BOTTOMS

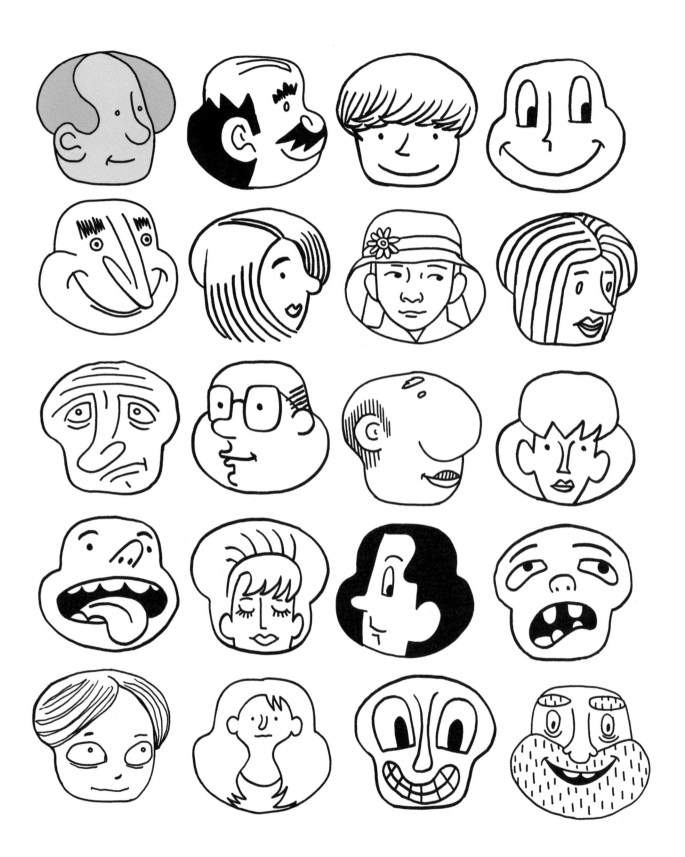

DRAW 20
Cupcake Characters

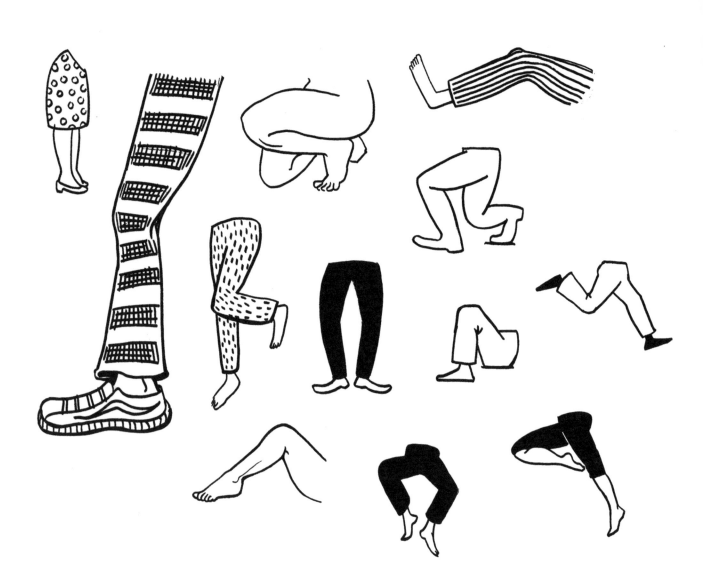

DRAW 20
LEGS

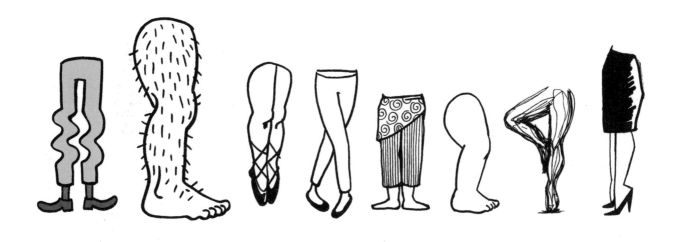

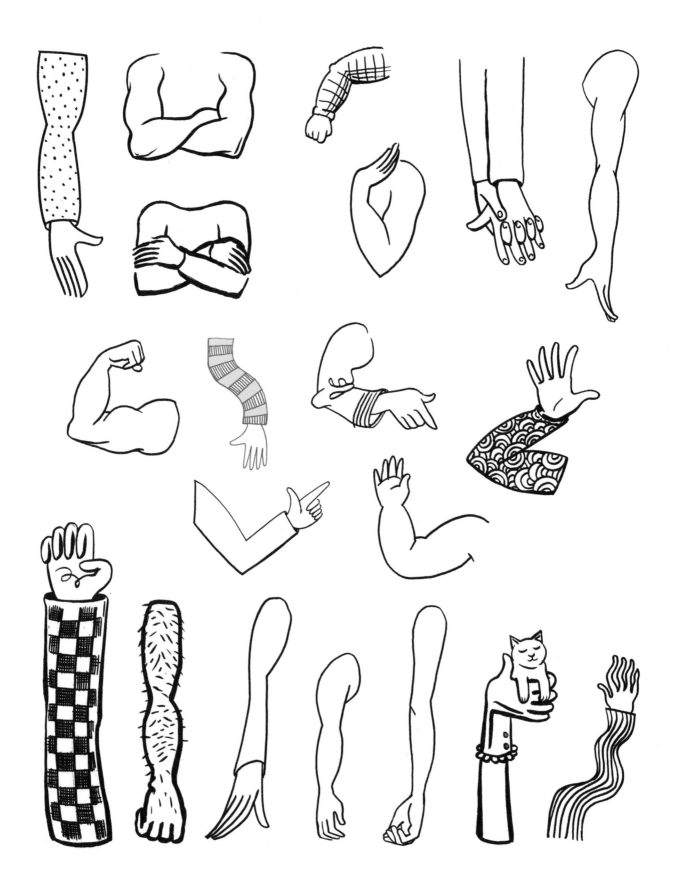

DRAW 20

Arms

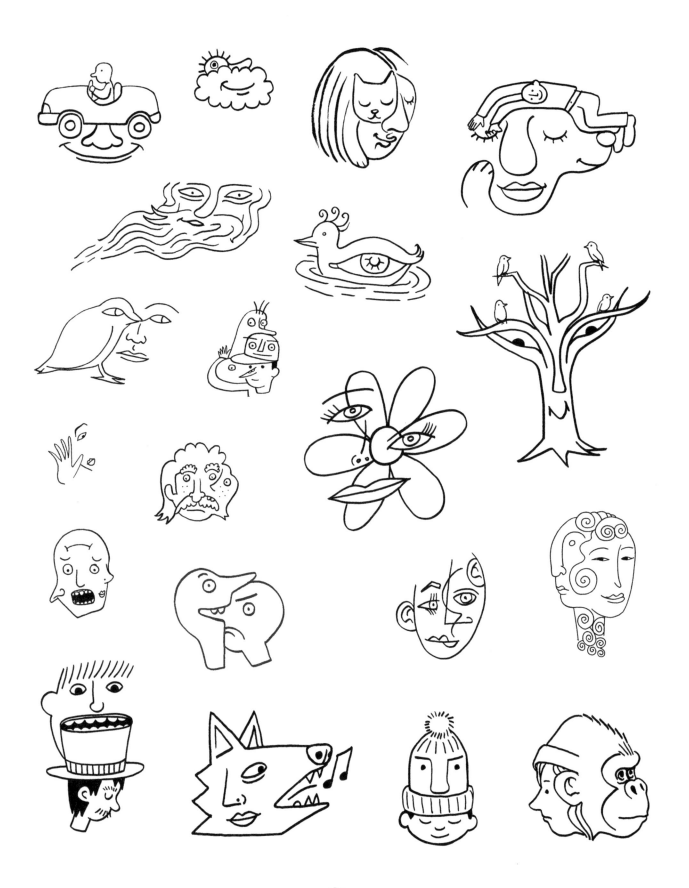

DRAW 20
DOODLE FACES

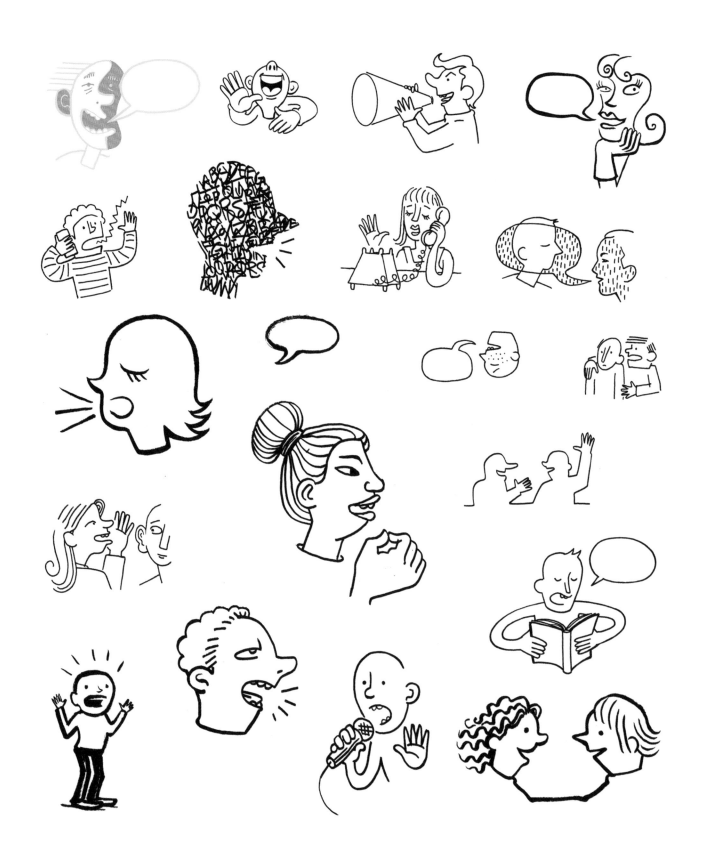

DRAW 20
People Talking

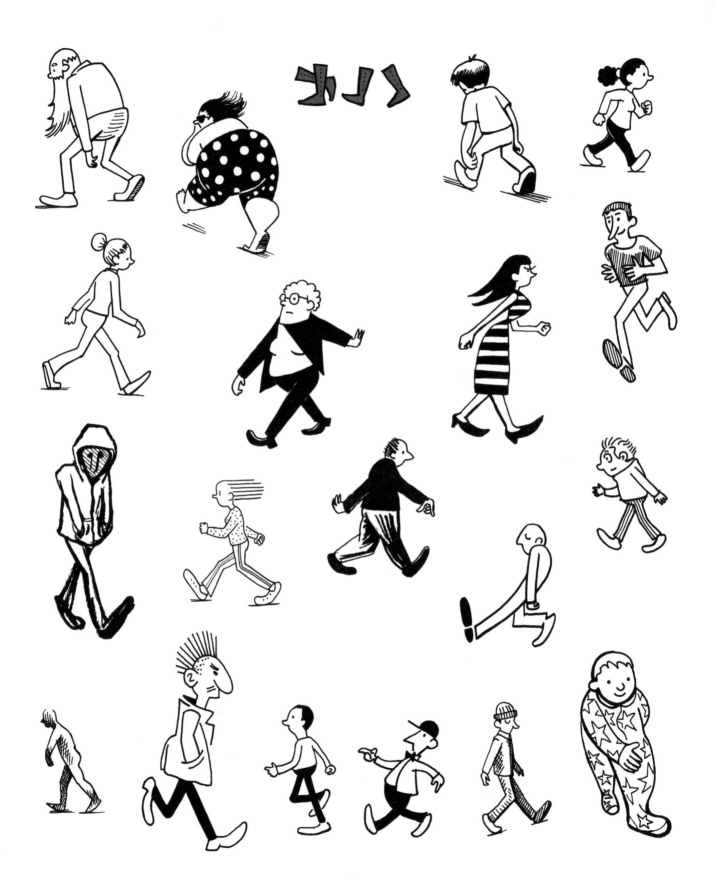

DRAW 20
walkers walking

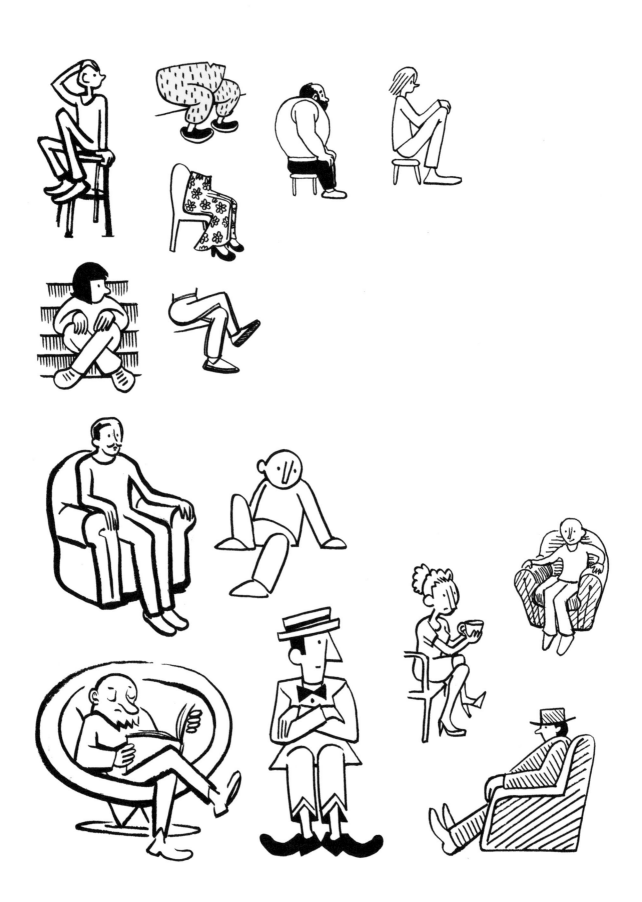

DRAW 20
Sitters Sitting

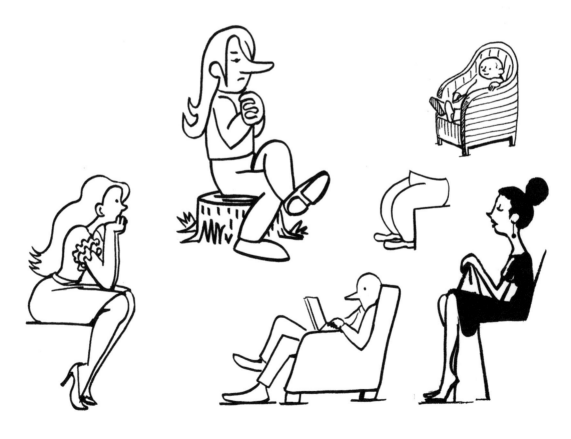

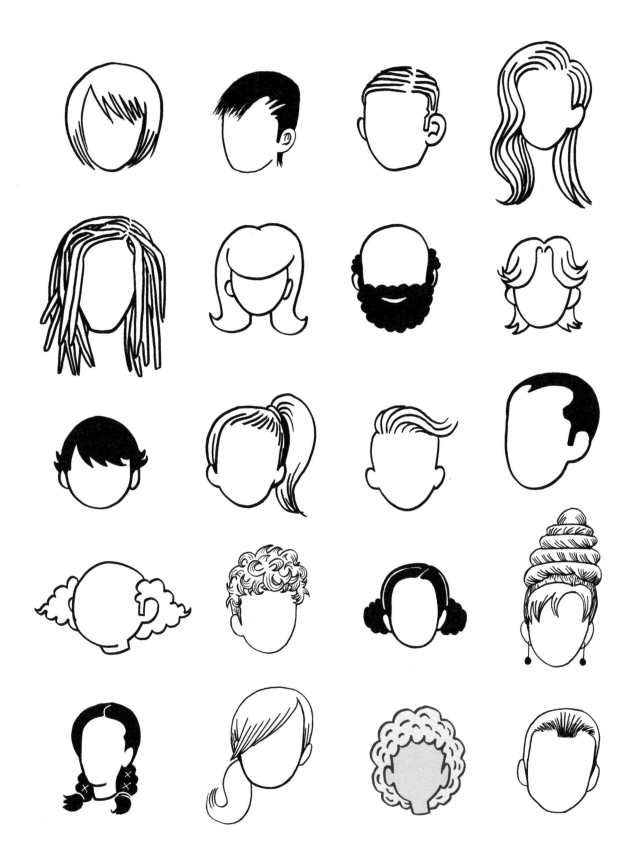

DRAW 20

Hairlines

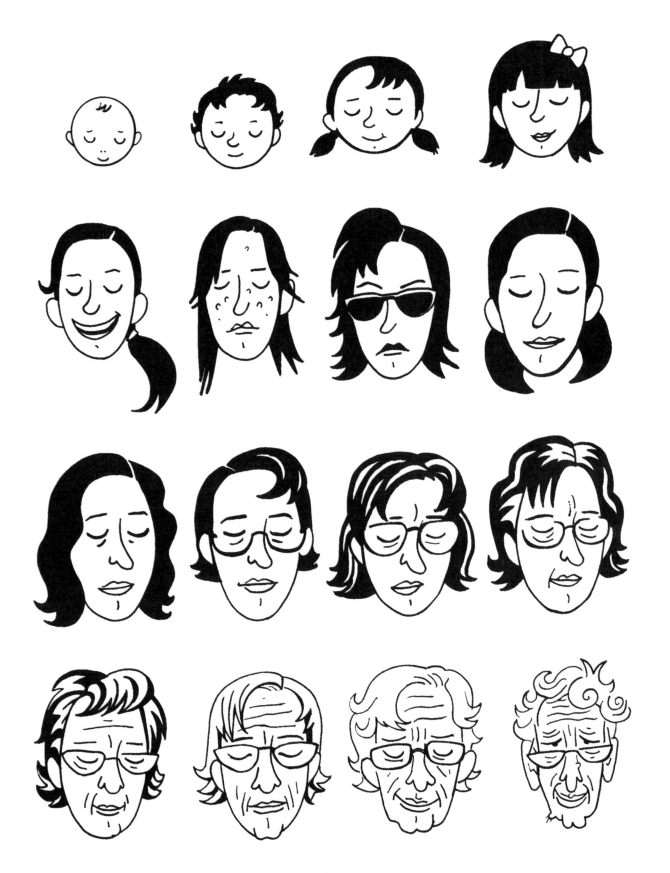

DRAW 20
Different Ages

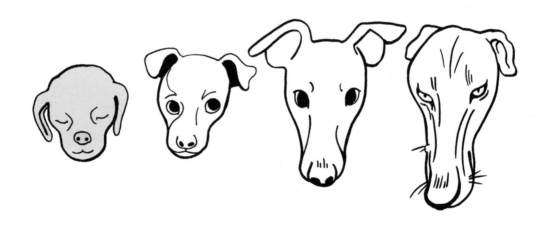

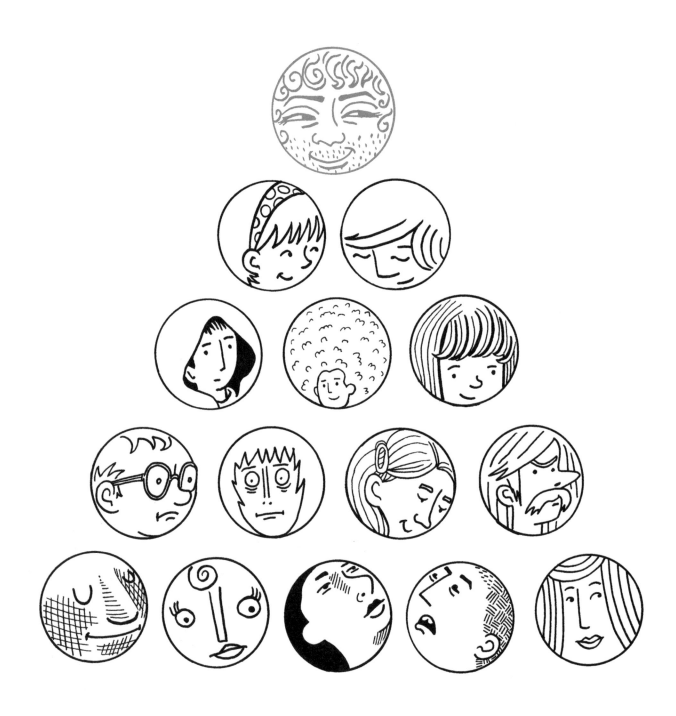

DRAW 20
CIRCLE
CHARACTERS

DRAW 20
Emotions

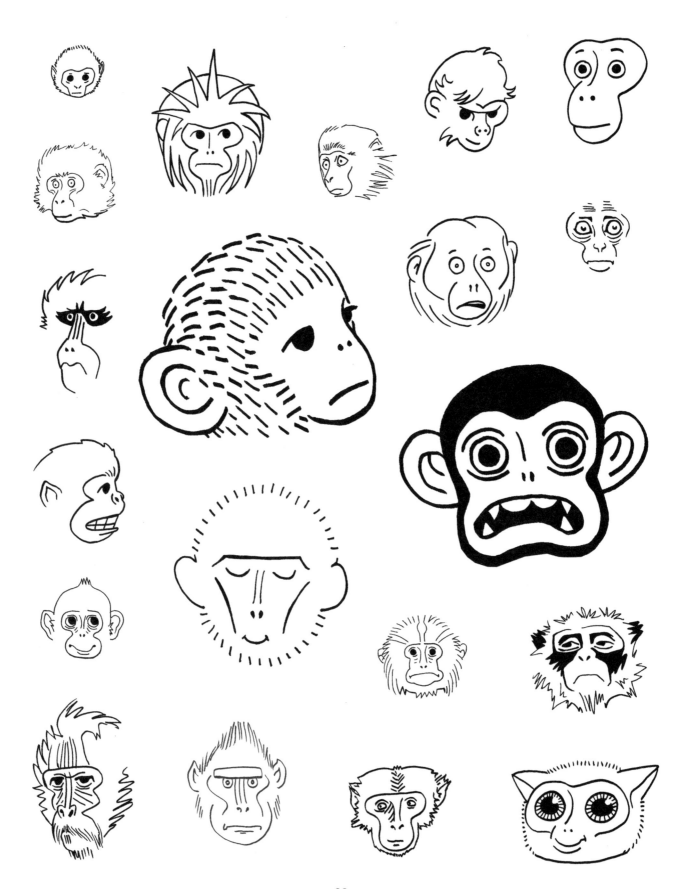

DRAW 20
Monkey Faces

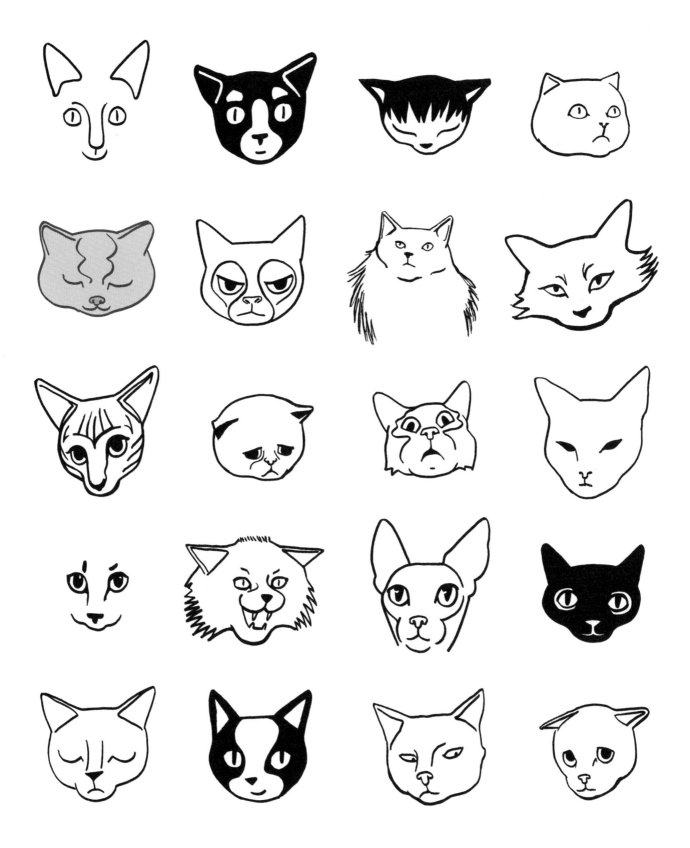

DRAW 20
Cat Faces

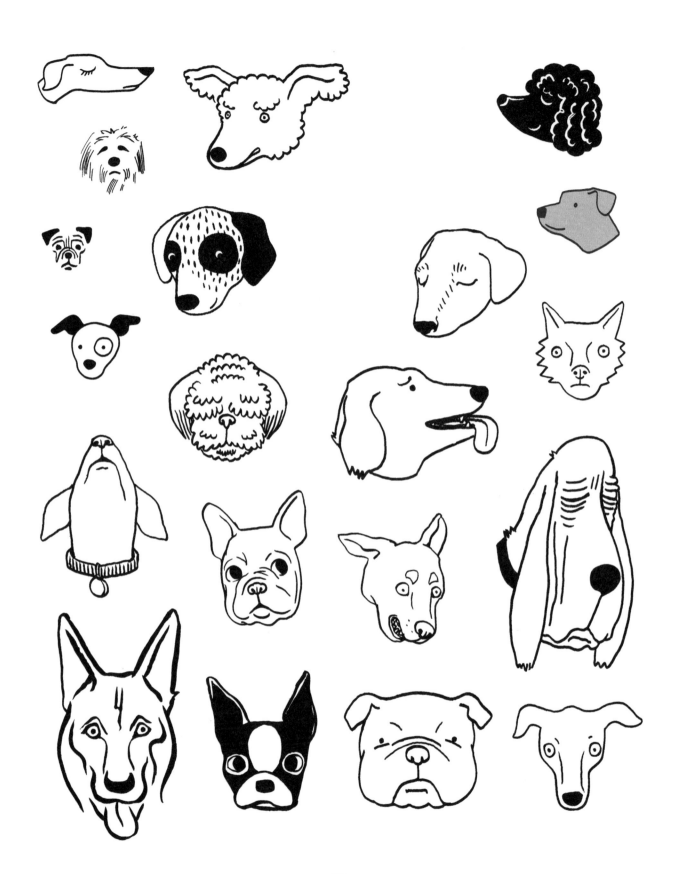

DRAW 20
Dog Faces

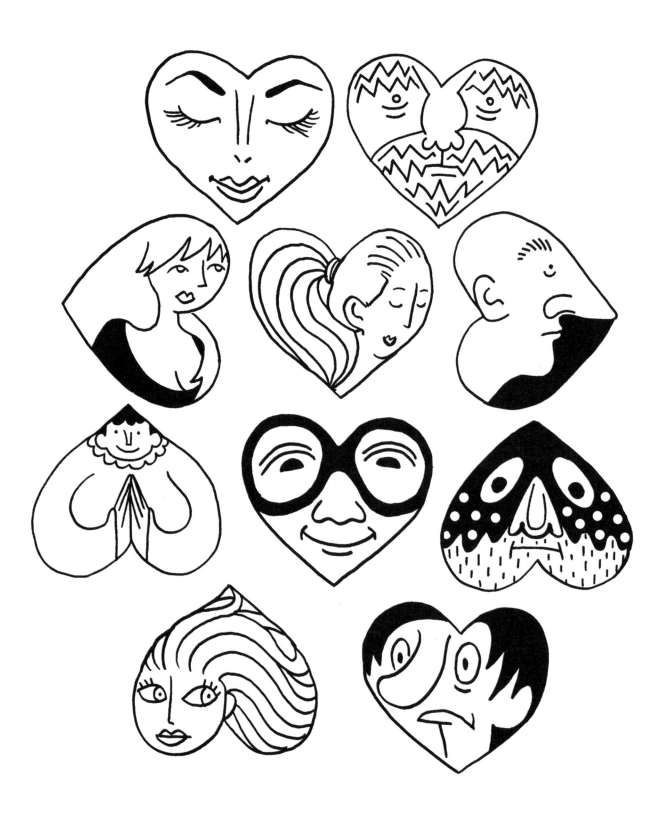

DRAW 20
Heart Characters

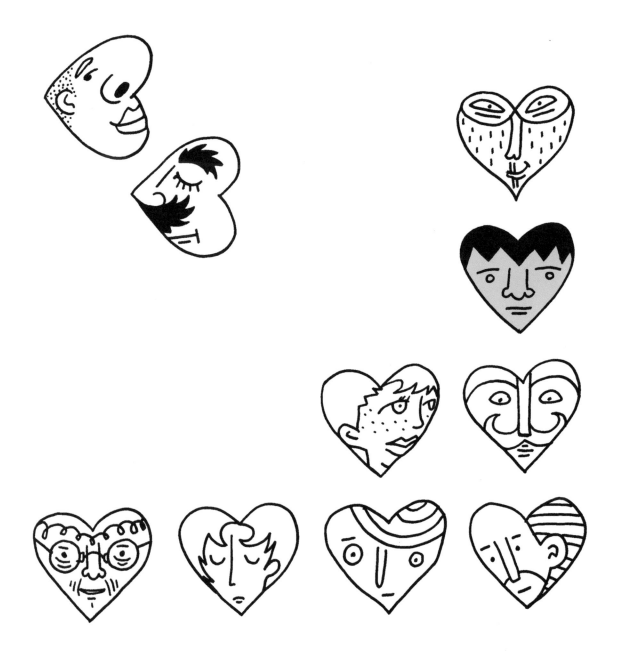

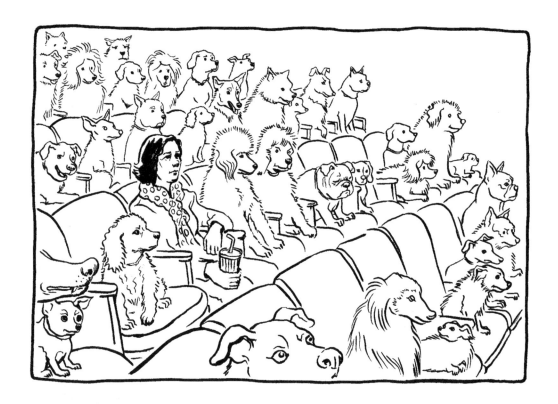

ABOUT THE ARTIST

Cara Bean is a cartoonist and art teacher from Concord, Massachusetts. She graduated with a master's degree in painting and drawing from the University of Washington, in Seattle. When she is not teaching, she makes comic books that relate to her life's experiences and fills sketchbooks with strange doodles. Cara likes: dogs, apes, tea, green hoodies, soup with crusty bread, people who walk alone and smile to themselves, hikes, mangos, befriending shy people, cats, libraries, thrift stores, Guadalajara, dancing with babies, crunchy leaves, owls, and nachos. Her students gather on Tuesdays after school for Illustration Club, which has become a place to draw and share ideas. Cara lives in a small cottage near Walden Pond with three wild dogs named Howie, Jackie, and Jon.

Learn more about Cara Bean at: badgigi.com, beandoodling.blogspot.com.